THE MONARCH OF THE GLEN

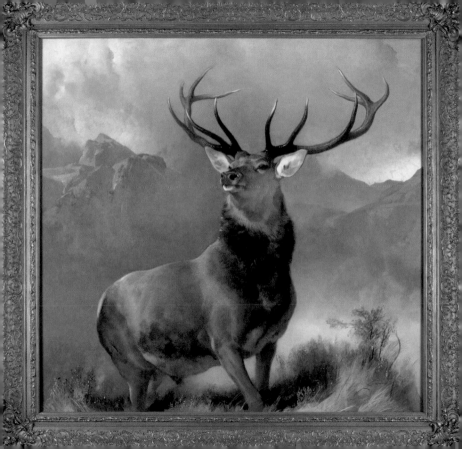

CHRISTOPHER BAKER

THE MONARCH OF THE GLEN
LANDSEER

NATIONAL GALLERIES OF SCOTLAND
EDINBURGH 2017

Published by the Trustees of the National Galleries of Scotland

Text © Trustees of the National Galleries of Scotland 2017

ISBN 978 1 911054 17 7

Designed and typeset in Sweet Sans by Dalrymple
Printed in the UK on Perigord 150gsm by Gomer

Frontispiece: Sir Edwin Henry Landseer, *The Monarch of the Glen,* c.1849–51, Scottish National Gallery, Edinburgh, fig.16
Front and back cover: details of fig.16

The proceeds from the sale of this book go towards supporting the National Galleries of Scotland. For a complete list of current publications, please write to: National Galleries of Scotland Publishing, Scottish National Gallery of Modern Art, 75 Belford Road, Edinburgh EH4 3DR, or visit our website: www.nationalgalleries.org

National Galleries of Scotland is a charity registered in Scotland (no.SC003728)

FOREWORD

Major acquisitions by public galleries can only be secured with considerable external support and when it became known in 2016 that Sir Edwin Henry Landseer's (1802–1873) celebrated *Monarch of the Glen*, c.1849–51, was to be sold and could – possibly – be purchased by the National Galleries of Scotland, the response was overwhelming. The rapid and very generous commitments of the Heritage Lottery Fund, Dunard Fund, Art Fund and Scottish Government, along with a number of trusts was brilliantly matched by the public. Contributions were received from around the world and this wave of goodwill, in combination with the very favourable terms offered by the owners, Diageo Scotland Ltd., meant that within four months it was possible to secure the picture for Scotland.

Since it was created in the mid-nineteenth century Landseer's painting, in spite of the fact that it is so well known, has remained in private and corporate collections: it now however, has become a national asset which can be shared, enjoyed and studied by more people than ever before. We are immensely grateful to everyone who supported the campaign to acquire this remarkable and resonant picture, both within the National Galleries of Scotland and beyond them: a list of all the benefactors is included in this book.

Sir John Leighton
Director-General, National Galleries of Scotland

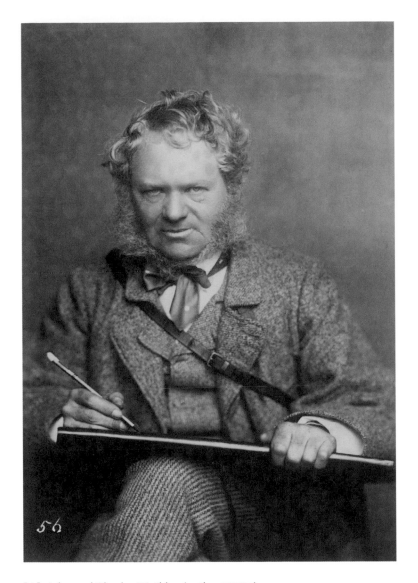

[1] John and Charles Watkins (active 1860s)
Sir Edwin Landseer RA (1802–1873), c.1867

Albumen print, 14.5 × 9.9 cm
Royal Collection Trust

INTRODUCTION

[Landseer's] greatest enjoyment was to wander in the lonely glens, or climb to the steep mountain-top, in search of that nature, animate and inanimate, with which his heart was in accord, and there it was that he derived the inspiration which prompted the greater part of his noblest productions.

Obituary from *The Report of the Council of the Royal Scottish Academy of Painting, Sculpture, and Architecture,* 1873

Few British paintings of the nineteenth century are as instantly recognisable as *The Monarch of the Glen.* It has so often been reproduced that it has become part of our shared visual memory. This familiarity means that it's hard to look at it afresh; that is, however, precisely what this book sets out to try and do, by placing the painting in the context of the career of the highly-accomplished artist who created it and considering some of the many different and contradictory interpretations it later inspired. These have ranged from it being seen as a splendid technical achievement and a romantic evocation of Scotland's wildlife, to it being viewed as an archaic image and an irrelevant aristocratic trophy. Through endless reproduction it has also almost become a kitsch icon, in a way that would have been inconceivable to Landseer and his contemporaries.

Today Landseer is not a household name. However, he was one of Victorian Britain's most successful and fêted artists [fig.1]. The breadth of the appeal of his work as an

animal painter is hard to recapture – it transcended class distinctions and had a global reach. His paintings were deeply admired by Queen Victoria and could be found reproduced in prints displayed in modest homes across Britain and its empire around the world. The drama, sentimentality and often sophisticated exploration of the complex interaction between people and animals found in his works, struck a chord with millions. Through the twentieth century, however, many aspects of Victorian culture were dismissed as outmoded and an impediment to progress: this included paintings of the period, which languished in gallery storerooms. *The Monarch of the Glen* intriguingly survived this fundamental shift in taste, as it had taken on a new role, being employed as a highly successful marketing image; as such its fame probably extended even further, although the original circumstances of its commission were long forgotten. It now has a complex and fascinating status in an age when Victorian art has been reassessed by scholars and is widely admired once again, but the élite associations that Landseer's *Monarch* conjures up are challenged as being at odds with some modern values and contemporary views of Scottish nineteenth-century history.

LANDSEER

Landseer's life and career encompassed soaring talent, public
adulation and private tragedy. He was born in London in 1802.
His father, John, was an engraver, writer and antiquarian and
Edwin was one of seven children, only two of whom did not
pursue artistic interests. The accounts of his early years all
suggest Landseer was a prodigy, who by the age of five was
drawing with exceptional skill and specialising in the subject
matter that was to become his life's work – the animal kingdom.
He studied domestic and farm animals and more exotic
creatures in menageries, and in 1815 first exhibited paintings
at the Royal Academy of Arts: one was a depiction of dogs – a
theme that was to engage him throughout his career, to such an
extent that a breed was later named after him. The young artist
received instruction from the history painter Benjamin Robert
Haydon (1786–1846), a man of immense although thwarted
ambition, who steered him towards a study of animal anatomy
and old master paintings. It was at this period that Landseer
also attended classes given by the Scottish anatomist Sir
Charles Bell. The precise red and black chalk drawings he
produced demonstrate great assurance and a desire to fully
understand the musculature and movement of animals [fig.2].
 Landseer benefitted from further training when he entered
the Royal Academy Schools at the age of fourteen; he was
regarded affectionately by his teachers and thrived in this
environment. His fellow academicians bestowed accolades on

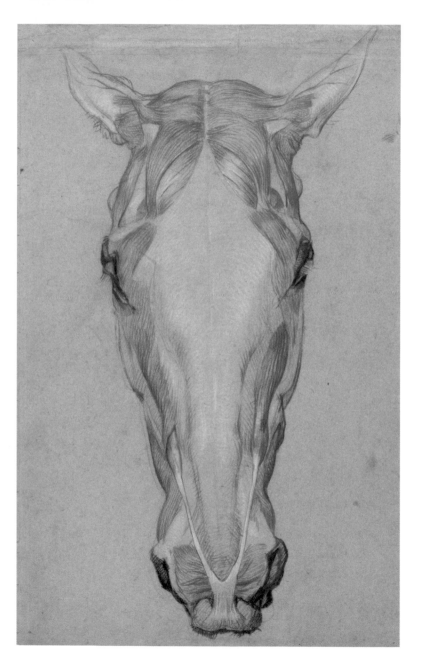

[2] Sir Edwin Landseer
An Ecorché Study of a Head of a Horse, c.1817–21

Black, red and white chalk on buff-coloured paper, 50 x 31 cm
Snite Museum of Art, University of Notre Dame, Indiana

him at an early age: in 1826 he was elected an Associate of the Academy and in 1831 became a full Academician (much later in 1866 he was also elected an Honorary Academician by the Royal Scottish Academy). In parallel with all this professional success Landseer soon secured patrons who were willing to pay handsomely for his animal and sporting pictures and delighted in his witty company. They were chiefly aristocrats, such as the Duke of Bedford and Duke of Devonshire, for whom the world of hunting was a traditional aspect of life on their vast estates. Landseer also attracted patronage from newly rich metropolitan collectors, like Robert Vernon and John Sheepshanks: wherever he appeared he was in demand for his charming conversation and ability to pen brilliant, fluid caricatures to amuse his hosts [fig.3]. The circles he mixed in extended far beyond the collectors who supported him, and he could count among his friends writers such as Charles Dickens and William Makepeace Thackeray and artists like Sir Francis Chantrey and Sir John Everett Millais.

In 1823 Landseer made the first of many visits to Woburn Abbey, the home of the Duke of Bedford, who became an important and indulgent patron. The Duke's formidable and rather racy second wife, Georgiana, was the daughter of the Duke of Gordon: she took a close interest in the young painter and Landseer became her lover. Their relationship was a focus of scandal, which was stirred up by Haydon, who by this time was jealous of his protégé's professional and social success. The Duchess appears in an especially accomplished sporting painting by Landseer of the mid-1820s, where she is splendidly dressed

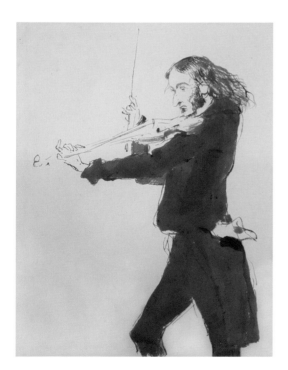

[3] Sir Edwin Landseer
*Niccolò Paganini Playing the Violin,*1840

Watercolour and ink
22.2 x 17.8 cm
Manchester Art Gallery

[4] Sir Edwin Landseer
Scene in the Highlands, with Portraits of the Duchess of Bedford, the Duke of Gordon and Lord Alexander Russell ('Sport in the Highlands'), 1825–28
Oil on canvas, 130.5 × 166 cm
Private collection, on loan to the Scottish National Gallery, Edinburgh

12

for outdoor pursuits holding a fishing rod, along with her brother and son [fig.4]. The scene is set in Glenfeshie, in the Cairngorms in the Highlands and is not only a tribute to Georgiana and her family, but also to Landseer's new enthusiasm for all things Scottish.

This passion was to remain with him for the rest of his life and was ignited in 1824 when he travelled north of the border for the first time. Landseer visited the celebrated novelist and poet Sir Walter Scott (1771–1832) at Abbotsford, near Melrose, journeyed to the Highlands and was entranced by the dramatic landscapes he encountered, as well as the people he met and what he considered to be the romance of Scottish history. His delight in the company of Scott is wonderfully conveyed by a freely painted and insightful portrait study of the writer at his desk [fig.5], which was produced only after he had depicted all of the dogs in Scott's household. Landseer's infatuation with Scotland resulted in annual sketching, hunting and fishing trips undertaken each autumn for many years, which provided a profound sense of liberation for the city-based painter. They led to the creation of a wide range of works, which included delightfully fresh landscape studies that display great sensitivity to the vagaries of Scottish weather [fig.6] and a number of Landseer's most famous sporting and animal pictures. He was also to produce complex historical

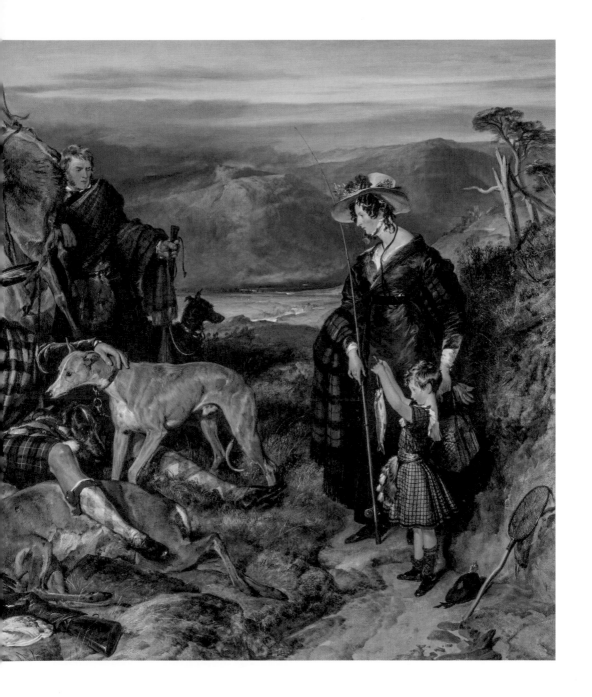

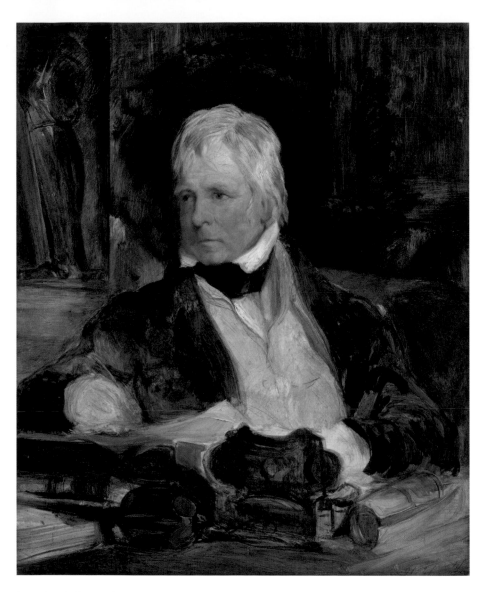

[5] Sir Edwin Landseer
*Sir Walter Scott 1st Bt, c.*1824

Oil on panel, 29.2 x 24.1 cm
National Portrait Gallery, London

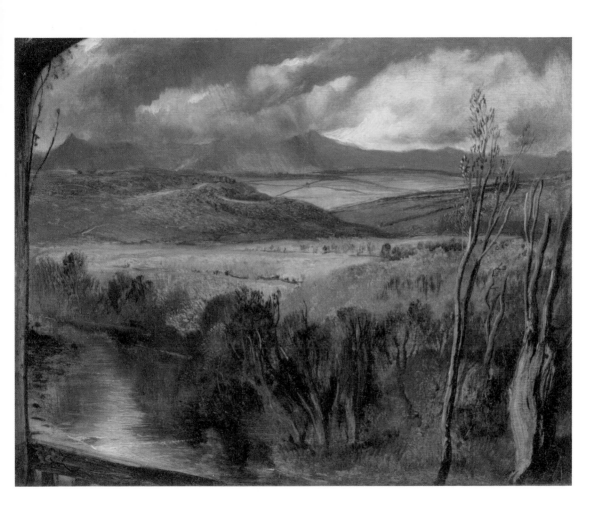

[6] Sir Edwin Landseer
*Highland Landscape, c.*1830–35

Oil on board, 20.3 x 25.4 cm
Yale Center for British Art, Paul Mellon Collection, New Haven

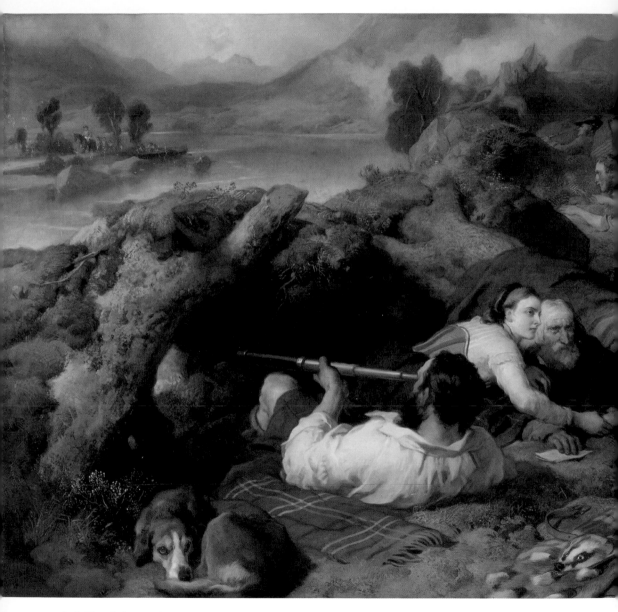

[7] Sir Edwin Landseer *Rent Day in the Wilderness,* **1855–68**

Oil on canvas, 122 x 265 cm · Scottish National Gallery, Edinburgh

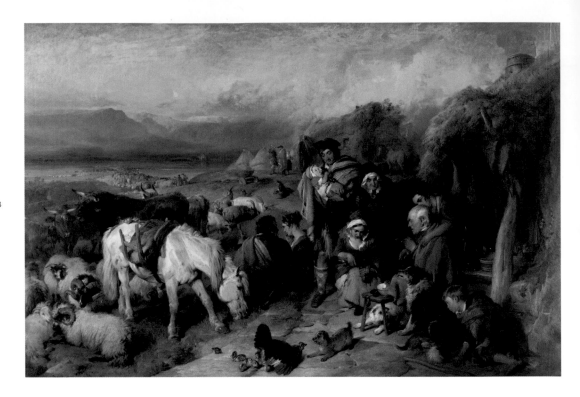

compositions, such as his depiction of Donald Murchison, who stoically resisted the incursions of the English forces during the Jacobite risings of the early eighteenth century [fig.7]. This highly unusual and complex commission was painted for Murchison's descendent, the distinguished geologist Sir Roderick Murchison. Contemporary Highland life was also explored in some ambitious compositions by Landseer. It tended to be viewed by the painter in a highly selective manner that was inevitably tailored to suit the outlook of his patrons. It helped to inspire the growing, romantic, tourist image of Scotland [fig.8], rather than documenting the reality of a period of turmoil and deprivation caused by the forced evictions known as the Highland Clearances.

With abundant talent and charm it is perhaps not surprising

[8] Sir Edwin Landseer
The Drover's Departure:
A Scene in the
Grampians, 1835

Oil on canvas, 125.8 x 191.2 cm
Victoria and Albert Museum
London

that Landseer soon came to the attention of the royal family. In 1837, the year of her accession to the throne, Queen Victoria first met the painter whom she described as 'unassuming, pleasing and very young looking.' The Queen and Prince Albert were to share a love of Scotland, which they first visited in 1842, as well as an enthusiasm for supporting living artists, and they commissioned and bought paintings from Landseer, including portraits, scenes of Highland life and sporting and animal pictures (thirty-eight works in oil along with a number of his fine drawings remain in the Royal Collection). Particularly successful among them are the paintings Landseer made of

19

[9] Sir Edwin Landseer
Eos, a Favourite Greyhound, the Property of H R H Prince Albert, 1841

Oil on canvas, 111.8 x 142.9 cm
Royal Collection Trust

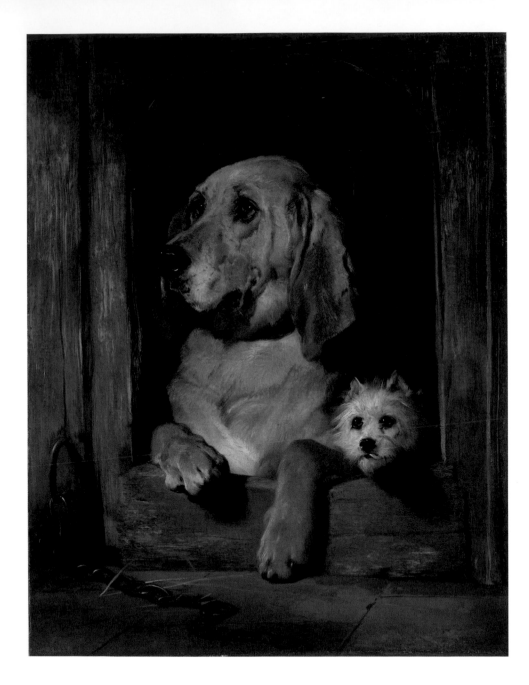

the royal couple's pets; perhaps the most accomplished of all was his portrayal of Prince Albert's favourite greyhound bitch, Eos [fig.9]. It combines the artist's uncanny ability to replicate with glowing precision the appearance of a specific animal, along with an unerring eye for an elegant composition. Landseer's relationship with the royal family was friendly but strained, not least because he felt it placed considerable demands on his time: The Queen knighted him in 1850 and she recalled in the 1870s how 'He kindly had shown me how to draw stags' heads…', but he memorably described her in a private letter as 'a very *inconvenient* little treasure.'

21

Far beyond the drawing rooms of Windsor Castle or Balmoral, the artist succeeded in keeping a high profile; he knew that to promote his work he needed to ensure its visibility and there were two key ways to achieve this: through exhibitions that were widely reported in the press and via the print trade, which provided high quality and affordable steel engravings, that reproduced his paintings for an eager public. An extraordinarily popular work, such as Landseer's *Dignity and Impudence* [fig.10], which is typical of the anthropomorphic character of a number of his most admired pictures, illustrates how these aspects of the art world were navigated. The picture was commissioned by Jacob Bell, a chemist and friend of Landseer, who owned the bloodhound and terrier it immortalises. It was exhibited in London, Birmingham, Liverpool and Manchester before being bequeathed to the nation in 1859 and was engraved by four different printmakers during the nineteenth century. Landseer controlled the quality of such prints with exacting care and received copyright payments for them. His fame and income increased in tandem.

The dashing, accomplished and wealthy painter appeared to have the world at his feet. But his public successes were brittle and in 1840 Landseer suffered a severe nervous breakdown. There were probably a number causes, including the stress he experienced because of the pressure to finish paintings,

the death of his mother, and disappointments in his private life. Landseer did gradually recover, but the experience cast a shadow over much of the rest of his career. Commissions and sales of works continued; however, the brio and life-affirming qualities he was renowned for as a young man diminished. They were succeeded by periods of depression, alcoholism, and, ultimately, insanity. In spite of these profound personal challenges Landseer succeeded during the second part of his life in creating some of the most ambitious of all his works, which include in the early 1850s *The Monarch of the Glen*, and then in the 1860s his largest and most public commission – the four sculpted lions placed at the base of Nelson's Column in the centre of Trafalgar Square in London. This very demanding project involved modelling the monumental lions, which were then cast in bronze by the sculptor Baron Carlo (Charles) Marochetti (1805–1867); they were based in part on life studies made at London Zoo, including a majestic oil sketch in the Tate collection [fig.11]. Although Landseer demonstrated such flashes of painterly brilliance in his later years, his behaviour became increasingly erratic, being characterised by bouts of hypochondria and violence. He continued, however, to receive accolades, such as a gold medal at the Exposition Universelle in Paris in 1855, and being offered the Presidency of the Royal Academy in 1866 (which he refused).

Landseer died in 1873 and was buried in the crypt of St Paul's Cathedral. He was widely mourned, being accorded the type of respect that would usually be given to a great statesman rather than an artist. Wreaths were placed in the jaws of the Trafalgar Square lions and in the following year a memorial exhibition was held at the Royal Academy. It included *The Monarch of the Glen* and over 100,000 visitors flocked to see it.

[11] Sir Edwin Landseer
Study of a Lion, c.1862
Oil on canvas, 91.4 × 137.8 cm
Tate, London

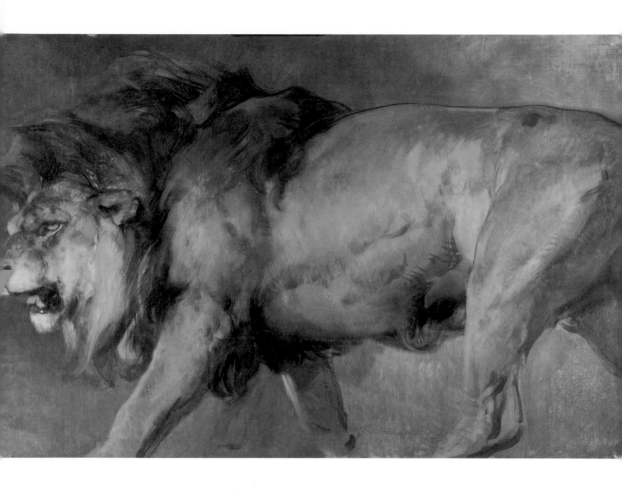

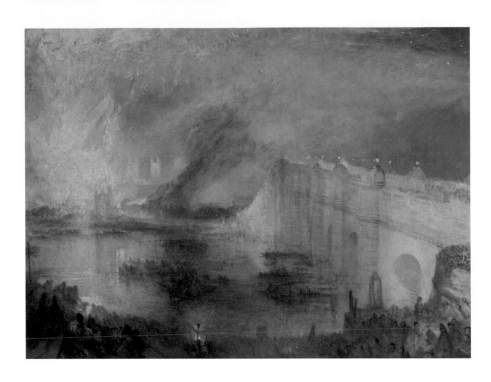

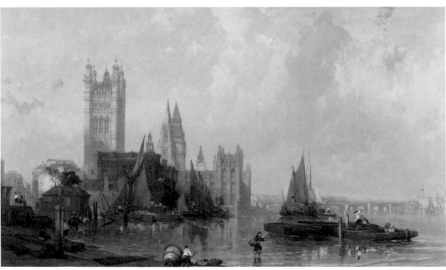

THE MONARCH OF THE GLEN

25

[12] J.M.W. Turner
(1775–1851)
*The Burning of the Houses
of Lords and Commons,
October 16, 1834,*
exhibited 1835

Oil on canvas, 92.1 x 123.2 cm
Philadelphia Museum of Art:
The John Howard McFadden
Collection, 1928

[13] David Roberts
(1796–1864)
*The Houses of Parliament
from Millbank*, 1861

Oil on canvas, 61 x 106 cm
Museum of London

It was a spectacular act of devastation that resulted in
Landseer receiving his commission for his most famous
painting. The ancient Palace of Westminster by the Thames in
London was consumed by fire in October 1834. The destruction
was watched by a number of artists, including Landseer's
tutor Haydon, and was recorded in an awe-inspiring manner by
J.M.W. Turner (1775–1851), who made the most of molten ashes
soaring over the city [fig.12]. With admirable speed, plans
were developed to rebuild parliament and the commission
for the design of the new palace was won by Charles Barry
(1795–1860), who created the gothic-revival masterpiece
that dominates Westminster to this day [fig.13]. Much of its
splendid interior decoration was designed by Augustus Welby
Northmore Pugin (1812–1852) and discussions were soon
underway about what sort of paintings might adorn the rooms
he planned.

The supply of works of art for the new Houses of Parliament
was overseen by the Fine Arts Commission, which was founded
in 1841. This was the brainchild of the Prime Minister Sir Robert
Peel who defined its purpose as 'the encouragement of British
Art' within the palace. Prince Albert became President of the
Commission and the artist and arts administrator Sir Charles
Eastlake was appointed its Secretary. The commissioners
were members of the two Houses of Parliament and 'amateurs'
who were chiefly artists and collectors. They defined what

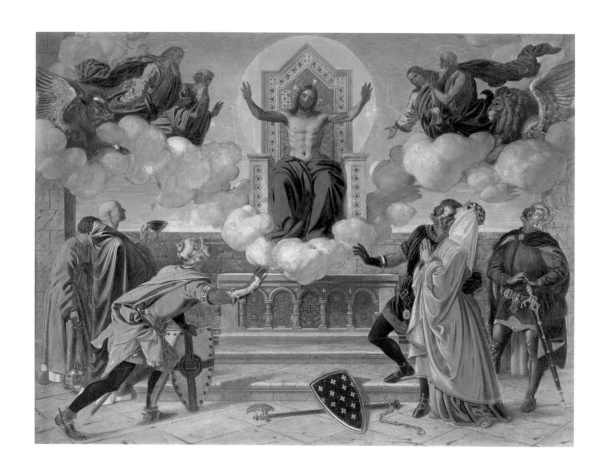

[14] After William Dyce (1806–1864)
Religion: The Vision of Sir Galahad and his
Company (after the fresco of 1851 in the Robing
Room in the House of Lords)

Hand coloured albumen print, 29.1 x 26.2 cm
Scottish National Portrait Gallery, Edinburgh

were considered appropriate subjects for different rooms and oversaw the process of initiating competitions and commissions in order to populate them. From the outset, the Commission especially favoured historical subjects and the use of fresco – grand themes, inspired by Italian Renaissance precedents [fig.14]. There was a slight softening of this rigorous agenda however, when proposals about the refreshment rooms (dining rooms) were considered [fig.15]. In 1847 the Committee decided that these should be decorated with 'Views of important and remarkable places': in the House of Commons this meant 'India and the Colonies' and in the House of Lords 'the United Kingdom'. It was also felt that there should be space for 'subjects connected with rural scenery, the Harvest, the Chase, etc.' Two years later Landseer was offered a commission that would focus on 'the chase', in other words hunting, a subject where his status as an artist was unrivalled. He was to paint three pictures and agreed to be paid one thousand guineas, although he noted in his correspondence

[15] A. Newman, after G. S. Clarke
The Peers' Refreshment Rooms

Coloured lithograph, published in H. T. Ryde, *Illustrations of the New Palace of Westminster*, London, 1849

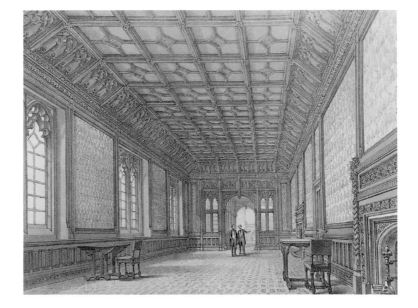

with Eastlake that a refreshment room might not be the most appropriate setting for his work. The artist developed *The Monarch of the Glen* [fig.16] to fulfil the commission, but the subjects he was considering for the other two canvases in the series remain obscure – this is not surprising as he had a reputation for taking a long time over his paintings and sometimes leaving them unresolved.

There was a debate in the Commons about the rising costs of the projects the Commission was promoting and it was decided not to endorse the growing expenditure of those intended for the Lords and so Landseer never completed his project. Alternative sites at Westminster were considered for his painting by Prince Albert and Eastlake, such as a staircase, but this proved to be unworkable. The artist had, however, given some careful consideration to the way in which it might have been displayed; the evidence for this appears in one of Sir Robert Peel's contributions to the debate on the 10 June 1850. Peel explained that with two other artists – Clarkson Stanfield (1793–1867) and David Roberts (1796–1864) – Landseer took an example of his painting into the refreshment room. The three men experimented by placing their canvases opposite the windows which ran all along one side of the room. It was concluded that this was not a suitable setting, but that at the end of the room the pictures might be advantageously placed where they would be 'lighted at the side.' Peel ended his discussion of the project with the statement that 'he did not believe there ever lived an artist of greater eminence than Mr Landseer.'

The painting may not have ended up in the location it was originally conceived for; however, its format and composition are in part explained by its intended setting. It is striking that it is almost square in format, which is somewhat unusual among the artist's works. This was presumably dictated by the space available in the panelling on the walls around the refreshment room. Furthermore, when hung comfortably above table height, the stag would have appeared as a commanding

[16] Sir Edwin Landseer
The Monarch of the Glen,
c.1849–51
Oil on canvas, 163.8 x 168.9 cm
Scottish National Gallery
Edinburgh

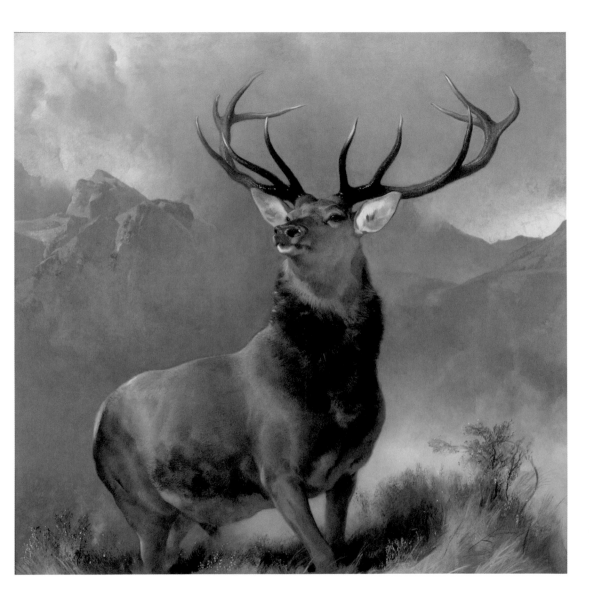

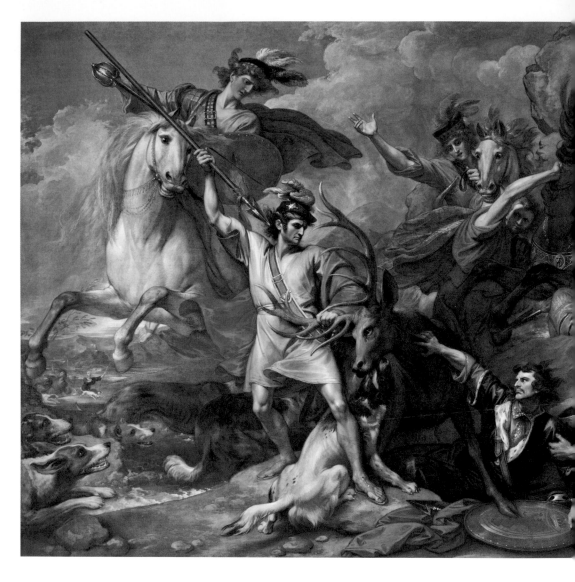

[17] Benjamin West (1738 – 1820) *Alexander III of Scotland Rescued from the Fury of a Stag by the Intrepidity of Colin Fitzgerald ('The Death of the Stag')*, 1786
Oil on canvas, 366 × 521 cm · Scottish National Gallery, Edinburgh

presence, imperiously surveying the diners below. Finally, he was presumably positioned so he would face the light from the adjacent windows.

Landseer's parliamentary commission also posed a particular challenge as most of the paintings for the new building were grand in every sense – not only being monumental in scale but also elevated in subject matter. Traditionally, animal painting had a lowly status in the academic hierarchy of subject matter, far below themes from human history and myth; so, in this setting it was especially important to make a strong claim for his chosen specialism and create an animal picture that was uplifting and celebratory. Landseer was certainly aware of the status that animal painting had in the past: admired masters such as Velázquez (1599–1660) or Rubens (1577–1640) excelled at depicting animals, but chiefly in support of human dramas and acts of heroism. In this tradition Benjamin West (1738–1820) had, for example, painted his vast *Death of the Stag* of 1786 [fig.17], which explored a legendary incident in which the Scottish king Alexander III was rescued. By contrast Landseer sought to create a sense of spectacle and to ennoble animals themselves through his work. There had been painters who provided precedents for this in the seventeenth century, such as Frans Snyders (1579–1657) and Paulus Potter (1625–1654), although perhaps the most compelling model was the great eighteenth-century artist George Stubbs (1724–1806). He is chiefly renowned for depicting horses, but also studied more exotic creatures found in the collections of his wealthy patrons. In some of his most renowned works he moved beyond the portrayal of individual animals to create archetypes which embodied strength, beauty and power in nature [fig.18] and Landseer was in his own distinctive manner also seeking to achieve this. Aside from these broad parallels there is a tangible link between the two men, as Landseer acquired Stubbs's outstanding anatomical drawings, which he no doubt studied closely.

Landseer's *Monarch* may have had all this artistic heritage behind it, but it was also formulated in the context of his own evolving ideas about how to address hunting subjects. He started painting deer in the 1830s and continued to explore such themes for the next three decades. It was in 1842 however, that the painter began to focus on a single stag in his works, treating it in an emblematic manner. His painting of that year called *The Sanctuary* [fig.19] shows a stag who has been pursued by hunters and found refuge on an island on

opposite
**[18] George Stubbs
(1724–1806)**
Whistlejacket, **c.1762**

Oil on canvas, 292 x 246.4 cm
National Gallery, London

Loch Maree in the Highlands. Dramatically silhouetted before the setting sun, it is a memorable image of salvation. The titles of other works by the painter that explore related themes, such as *The Stag at Bay*, c.1846 (Dublin Castle, on loan from the Guiness family) and *The Hunted Stag*, c.1859 (The Beaverbrook Art Gallery, Fredericton) convey the elements of pursuit, threat and pathos that characterise them. What distinguished *The Monarch of the Glen* from such canvases is its euphoric, triumphal quality; it shows an animal in command of its environment and not – as yet – at the mercy of pursuers.

[19] Sir Edwin Landseer
The Sanctuary, **1842**

Oil on canvas, 61.3 x 152.7 cm
Royal Collection Trust

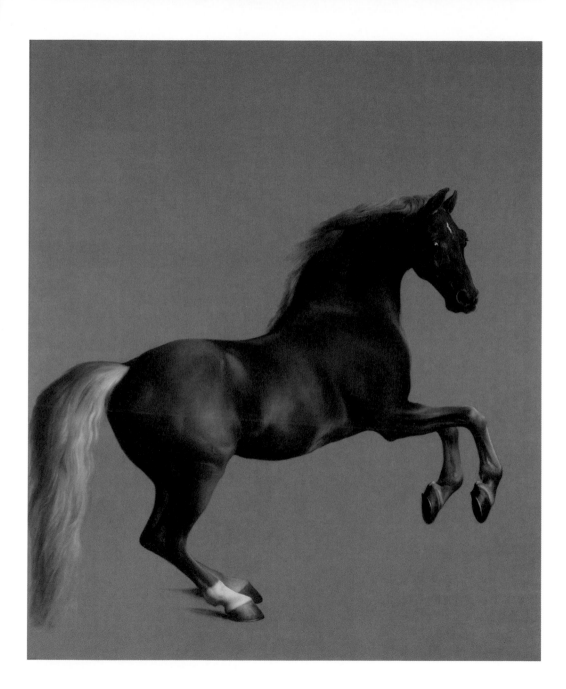

The artist's own conflicted opinions on hunting probably also influenced the range of scenarios found in such works. He undoubtedly enjoyed the life of a country sportsman and the chase, but had an intense dislike of cruelty and wrote in a letter of 1837: '… who does not glory in the death of a fine stag? … when in truth he ought to be ashamed…', noting '… the animal's inoffensive character' and '… my love of him *as a subject for the pencil*… picturesque and never ungraceful.' This ambiguity needs to be considered in the context of the complex and changing perception of the natural world in Victorian Britain. It was seen as a realm to be dominated for pleasure, sport or resources and was still regarded by many as a divine gift. There was also a growing awareness of the issue of animal welfare, and scientific understanding of the natural world was soon to make a profound, and for some unsettling, leap forward with the formulation of the theory of evolution. It would be wrong to suggest that Landseer was distilling his thoughts on such issues in a single painting, but they undoubtedly form part of the broader cultural and intellectual backdrop to it. In some respects, Landseer's *Monarch* can also be seen as a late illustration of the British preoccupation with the 'sublime' – a concept articulated and refined in the eighteenth century – which essentially meant that you could take visceral pleasure from the awe-inspiring forces of nature. These might be expressed through an overwhelming landscape or a powerful creature at liberty. Such themes continued to appeal to an increasingly industrialised and urban population who delighted in the escapism provided by images of a wilderness, just as they would in exotic, foreign themes.

The painting Landseer created, which inspired such awe, is a carefully contrived work of dramatic fiction intended to transport the viewer to the Highlands and evoke the drama of hunting. Stalking deer involves the stealthy pursuit of them on foot prior to taking aim with a rifle. It is often done today,

as it was in the nineteenth century, following the guidance of an expert stalker or ghillie [fig.20]. The aim is to get as close as you can before being sensed by your quarry; although it would be virtually impossible to get so near to such a stag in the wild as we are allowed to through Landseer's painting,

[20] David Octavius Hill (1802–1870) and Robert Adamson (1821–1848) *Mr. Finlay, Deerstalker in the Employ of Campbell of Islay, c.1845*

Calotype print, 20.5 x 14.5 cm Scottish National Portrait Gallery, Edinburgh

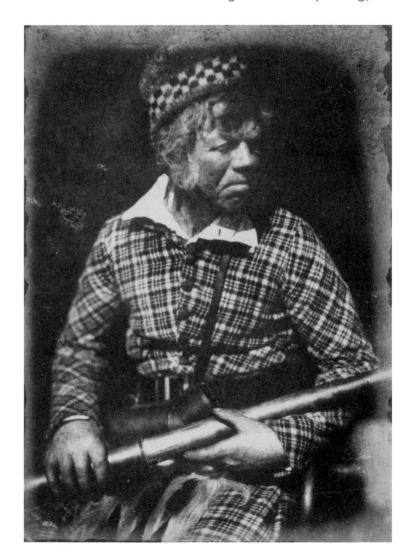

opposite and following pages
[figs 21–23] Sir Edwin Landseer
The Monarch of the Glen, c.1849–51
Details of fig.16

36 however accomplished you were. The artist provides us with
a privileged 'close-up' view, of the sort enjoyed in nature films
thanks to telephoto lenses. This impression is enhanced by the
truncation of the *Monarch*'s legs and the extraordinary care
with which the details are defined [figs 21–23]: the moisture
around the stag's nostrils, his delicate eyelashes and the
precise rendering of the colour and texture of his antlers, which
are crowned with twelve tines or points that identify him as a
'royal' stag. These elements all convey a compelling sense of
actuality which makes it easy to forget the painting was in fact
created in the context of an urban studio.

Landseer's studio formed part of his home in St John's
Wood Road, west of Regent's Park in central London. This
house, which no longer survives, was gradually expanded
during his career and in fact included two studios and a
'sketch room'. The larger studio was arranged so that the
easel Landseer worked on was brightly lit, while the rest of
the space was left in gloom. The house was surrounded by an
extensive garden used to accommodate a menagerie which
evolved over the artist's life and included dogs, sheep, horses
and deer (as well as a raven left behind by Charles Dickens).
When the contents of Landseer's home were sold after his
death over thirty pairs of stags' heads and antlers were listed
among his possessions. This rich visual context helps at least
partially explain how the artist was able to create such a sense

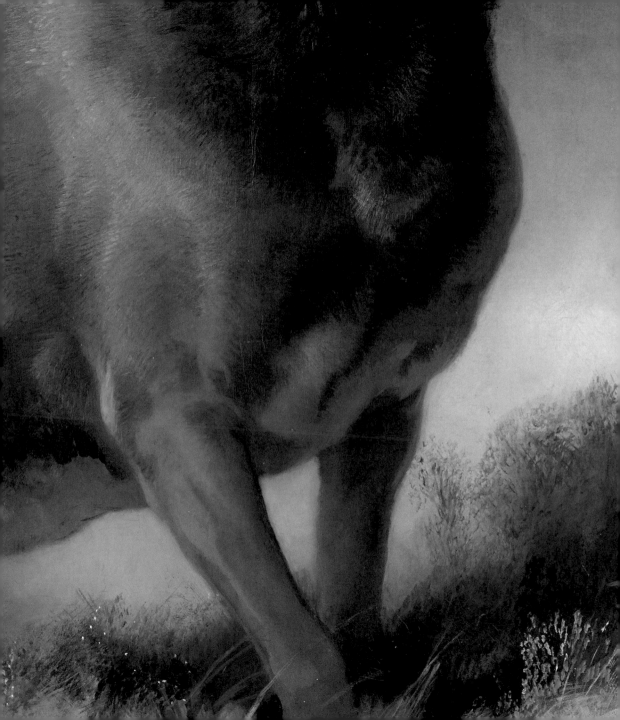

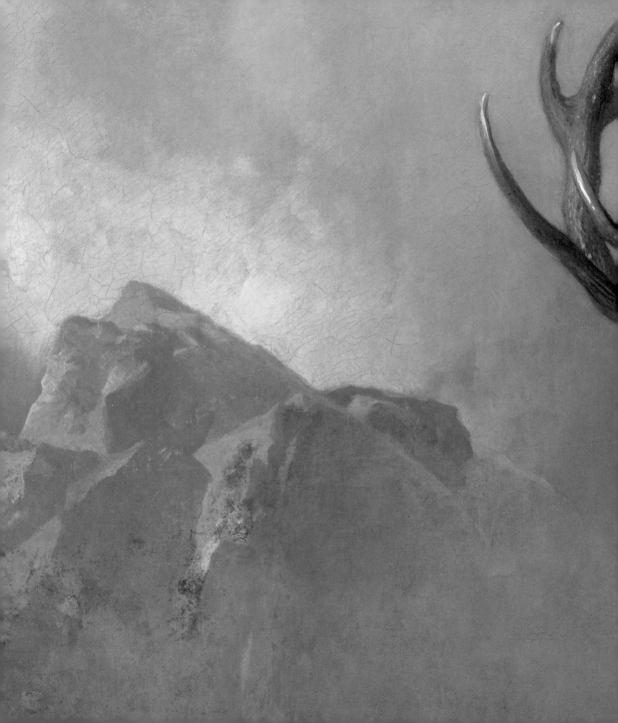

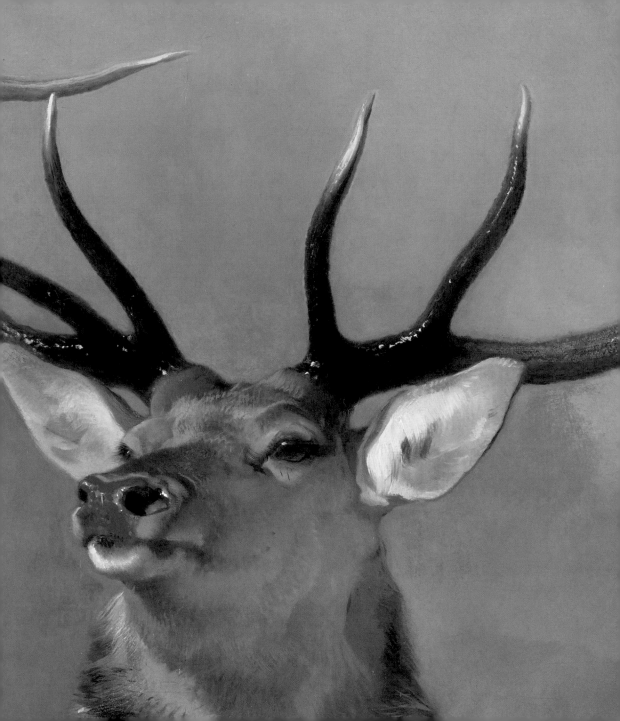

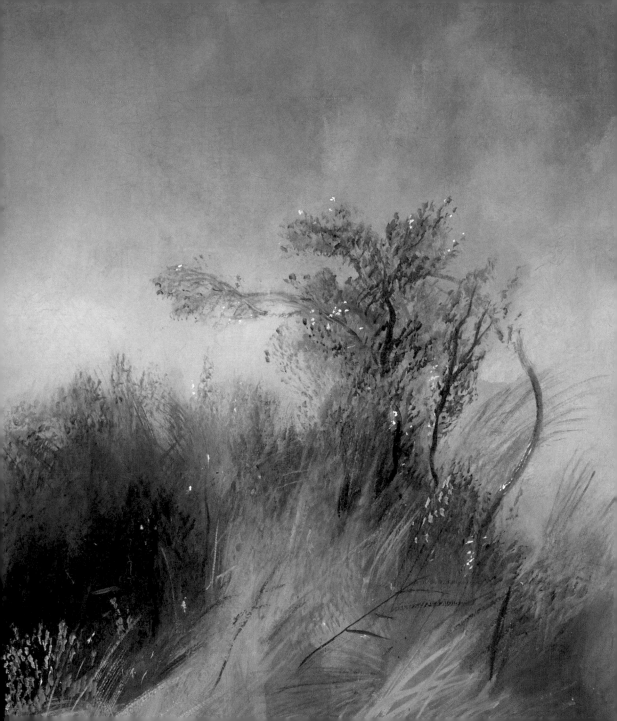

of immediacy and vivacity in works like *The Monarch of the Glen*: he could distil many years' worth of drawings [fig.24] and oil sketches of animals and landscapes which he had retained and when necessary, directly study actual specimens or live animals. In addition, his own experience of the Highlands and the sense of exhilaration the mountains there inspired must have informed his work.

The setting chosen in this instance, with steep rock faces at the left, and the mountains defined in greys and pinks with billowing clouds and mist rising from the glen, does look specific. Landseer appears to have suggested its identity when he first exhibited the painting at the Royal Academy

41

[24] Sir Edwin Landseer
A Dead Stag, 1840s

Black and white chalk on brown paper, 27.7 x 37.9 cm
Scottish National Gallery
Edinburgh

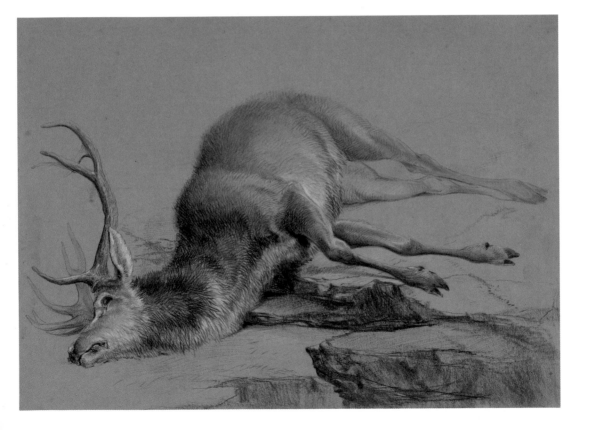

and included in the accompanying catalogue lines from an anonymous poem called *Legends of Glenorchay*:

> When first the day-star's clear cool light,
> Chasing night's shadows grey,
> With silver touched each rocky height
> That girded wild Glen-Strae
> Uprose the Monarch of the Glen
> Majestic from his lair,
> Surveyed the scene with piercing ken,
> And snuffed the fragrant air.

The forests of Glenorchay are on the Blackmount estate in north Argyllshire, which belonged to Lord Breadalbane, and which Landseer had often visited. However, it's also been suggested that the rocks look like a formation in Glen Quoich in Aberdeenshire.

The source of the poem is as mysterious as the setting of the picture and it is conceivable that it is by Landseer himself. Whoever wrote these lines may well have been familiar with Sir Walter Scott's work, as they echo his own *The Stag Hunt*:

> ... The antlered monarch of the waste
> Sprung from his heathery couch in haste...
> ... A moment gazed adown the dale,
> A moment snuffed the tainted gale,
> A moment listened to the cry,
> That thickened as the chase drew nigh...

These verses formed part of *The Lady of the Lake*, which was first published in Edinburgh in 1810, became immensely influential, and was inspired by Scott's experiences in the Trossachs and so provide yet another possible location. Perhaps Landseer conflated his experience of all these places across Scotland in this one memorable image.

FROM PRIVATE COLLECTIONS
TO POP ART

The year 1851 was something of a watershed in the history of British art. London was welcoming thousands of visitors who were pouring in to enjoy the spectacle of The Great Exhibition in The Crystal Palace at Hyde Park. Landseer had achieved by this point in his career a formidable reputation and had no difficulty promoting his latest work. On 8 April, after breakfast at Buckingham Palace, Queen Victoria and Prince Albert visited his house in St John's Wood. They inspected the six paintings he had decided to send to the Royal Academy's exhibition over the summer which demonstrated the full range of his talents. The Queen noted in her Journal how impressed she was with the works, including '... a life size stag, sniffing the air, with mist rising from the mountains.' The Academy was at this period based within the National Gallery in Trafalgar Square and it was a remarkable moment at which to contribute to its annual showcase exhibition, as a number of key pictures by the Pre-Raphaelites (who had established their Brotherhood in 1848) were also on display. In contrast with Landseer, their efforts drew scorn from the press, which led to the famous defence of Pre-Raphaelitism undertaken by John Ruskin (1819–1900). Landseer's paintings were admired, and immediately after this particularly contentious exhibition, his *Monarch* was sold to Albert Denison, 1st Lord Londesborough, a diplomat, liberal politician and collector of antiquities.

The following year the painting remained in the public eye as it was engraved by the artist's brother Thomas [fig.25]; a large print was published by Henry Graves & Co., who paid £500 for the copyright and three hundred artist's proofs were sold at ten guineas each. An unlimited number of smaller prints were also issued. The painting was then exhibited again at the Royal Academy in 1874 in Landseer's memorial exhibition, for which 30,000 catalogues were sold, and in 1884 it was acquired by another private collector, Henry William Eaton, 1st Lord Cheylesmore, a businessman with a taste for contemporary artists' work. He owned a number of paintings by Landseer, including *Flood in the Highlands*, by 1860 (Aberdeen Art Gallery & Museums), as well as canvases by David Roberts and William Powell Frith (1819–1909); his most significant European acquisition was Paul Delaroche's monumental *The Execution of Lady Jane Grey*, 1833 (National Gallery, London).

The next owner of Landseer's canvas brought about a transformation in its status. It was through his influence that it moved from the rarefied realm of private collections to becoming an unapologetically commercial asset. Thomas James Barratt (1841–1914) became a highly successful chairman of the soap manufacturer Pears and is chiefly remembered as a pioneer of the advertising industry. He is reputed to have said 'any fool can make soap. It takes a clever man to sell it'; he invested a great deal of money in adverts, developed the idea of celebrity endorsements (using figures in the public eye like Lillie Langtry) and bought works of art to promote, through reproduction, particular products. The painting that was most effectively exploited by him in this manner was Millais's *Bubbles*, 1885–86 (Lady Lever Art Gallery, Port Sunlight) a so-called 'fancy picture', in which the artist depicted his grandson in the guise of a traditional vanitas subject that conveys the idea that human life is as fleeting and insubstantial as a bubble. It proved to be a brilliant coup to align such a work of art and advertising – or painted bubbles

44

[25] Thomas Landseer (1793/4–1880), after Sir Edwin Landseer *The Monarch of the Glen*, published 1851

Etching
Royal Collection Trust

and soap – and Pears benefited spectacularly in terms of recognition and commercial success [fig.26]. There was though contemporary debate about whether such an initiative resulted in the democratisation of art or compromised an artist's integrity (Millais had in fact agreed to the use of his work in this manner).

This all formed the backdrop to the next episode in the remarkable history of Landseer's painting when in 1916 it was acquired by Thomas Dewar, 1st Baron Dewar (1864–1930). Dewar was a highly successful whisky distiller who, with his brother Lord Forteviot, cleverly blended whiskies and proved especially adept at marketing in a manner inherited from Barratt; he recognised the benefits of associating his products with Scottish imagery. What could be better than to appropriate *The Monarch of the Glen* in this context? It was used subsequently to promote whisky in numerous adverts and the alignment between the painting and the product was not just made visually, but also through various catchphrases, such as 'Dewar's The Monarch of Whiskies' and 'A strong link of Companionship, and both from the Glens. One is Landseer's Monarch and the other Dewar's'. As Scottish whisky is globally appreciated, this branding led to an unprecedented status for Landseer's work as a world-wide marketing icon [fig.27]. It is unsurprising that in the wake of such success it was also appropriated by many other campaigns, ranging from the promotion of shortbread biscuits to butter, as well as being used on innumerable Scottish souvenirs.

So the painting and its title gradually infiltrated the public consciousness far beyond the arena of exhibitions and collections. The recognition this achieved

46

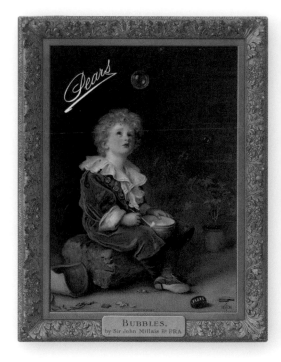

[26] After Sir John Everett Millais (1829–1896)
Pears' Soap advertisement, using 'Bubbles', 1886
Private collection

meant that it could also be employed to serve a wide range of other artistic and political agendas, which were sometimes highly inventive. Back in 1914 Landseer's picture had been used as the source for a cartoon in *Punch* magazine which showed the stag being ridden by the Liberal politician and

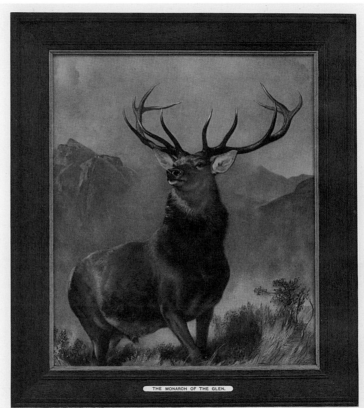

[27] Advertisement for Dewar's whiskey featuring Edwin Landseer's painting, *The Monarch of the Glen*

The *Illustrated London News*, 10 September 1927

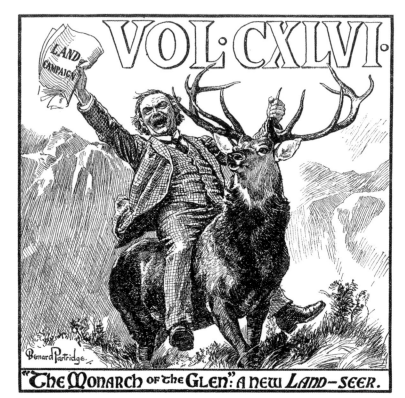

[28] Bernard Partridge
(1861–1945), after Sir Edwin
Landseer
"'*The Monarch of the Glen*':
A New Land-Seer"

Published in *Punch*, 7 January 1914
Punch Limited

Prime Minister David Lloyd George (1863–1945) [fig.28].
Drawn by the ingenious cartoonist Sir Bernard Partridge
(1861–1945), it utilises a pun on the artist's name to highlight
a political point: the caption reads "'The Monarch of the Glen':
A New Land-Seer" and refers back to the so-called 'People's
Budget' of 1909 in which Lloyd George as Chancellor of the
Exchequer had dramatically increased taxes on land values as
one of a number of initiatives to redistribute wealth. This led
to anger in the House of Lords, especially among the owners
of great estates, and it was presumably because that was the
original intended location for Landseer's painting that it was
utilised in this way.

The title of the painting, rather than the name of the artist, could also be effectively redeployed. It was adopted by the witty writer Sir Compton Mackenzie (1883–1972), who delighted in Scottish themes for his fiction and was a devoted nationalist. His most well-known comic novels are *The Monarch of the Glen* (1941) [fig.29], which is set in the Highlands and *Whisky Galore* (1947) which is located in the Outer Hebrides. The latter was used as the basis for an Ealing comedy two years after it was published. However, it was not until 2000 that the 'Monarch of the Glen' reached the screen, when it was employed as the inspiration for a long-running BBC television series. Starring Richard Briars, Susan Hampshire, Alastair Mackenzie and Julian Fellowes, this highly successful gentle farce plotted the chaos and romance of life in fictional Glenbogle.

In a spirit of parody, although of a rather different kind, *The Monarch of the Glen* was also reinterpreted afresh by the cartoonist Ronald Searle (1920–2011), who remains perhaps most well known as the creator of the anarchic St Trinian's school. He made a series of drawings that were published in *Punch* in 1956 entitled *As Picasso might have seen it*. These included pastiches of the work of Frans Hals and Millais as well as Landseer, reimagined in the manner of Picasso's work [fig.30]. Here the stag was transformed into an alarming, agonised creature against a dark backdrop, a distant relative of animals in Picasso's *Guernica*, 1937 (Museo Reina Sofia, Spain). It is an especially witty conceit,

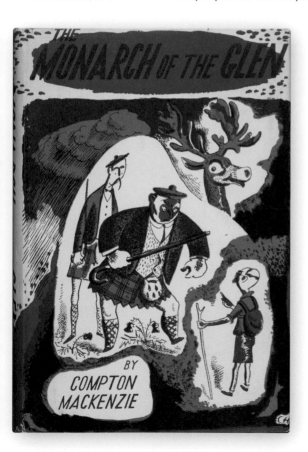

[29] Clarke Hutton (1898–1984) book cover *'The Monarch of the Glen'* by Compton Mackenzie

Chatto & Windus, 1941

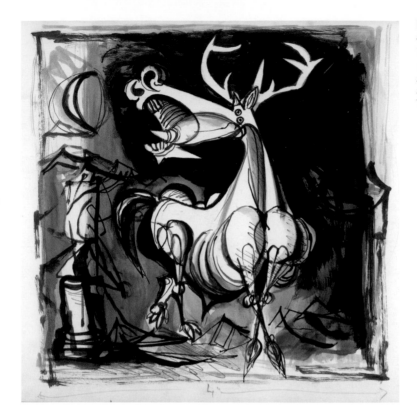

[30] Ronald Searle (1920–20?
after Sir Edwin Landseer
The Monarch of the Glen, 1956

Pen and brush, washed, on card,
27.1 x 37.8 cm, published in *Punch*,
24 October 1956
The Ronald Searle Cultural Trust

as the taste for Victorian art had rapidly fallen away in the twentieth century and reached a nadir by the 1950s, precisely because of the rise of modernism, of which Picasso was considered the supreme exponent.

Overexposure through advertising had perhaps by this period also led to Landseer's work being seen as a vulgar image and this in turn led to it inspiring affection, sometimes ironically and on other occasions in a heartfelt manner. The by now profoundly unfashionable *Monarch* was taken up once again as an artistic inspiration by Peter Blake (b.1932) in the mid-1960s [fig.31]. Blake was respectful to his source, which he studied through a reproduction, but assertively painted

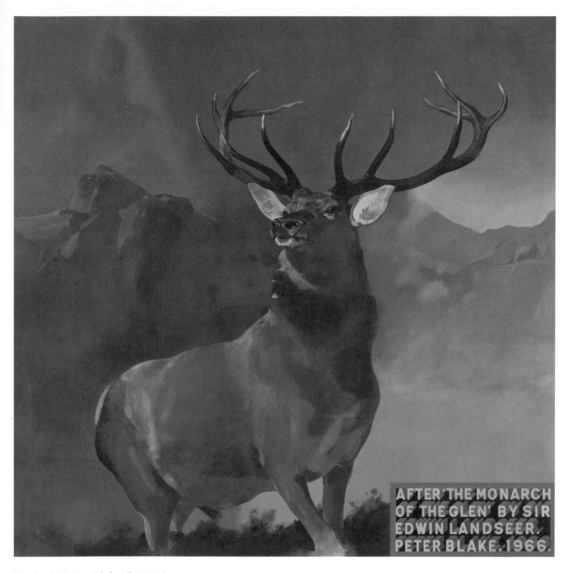

Within the image:

AFTER 'THE MONARCH
OF THE GLEN' BY SIR
EDWIN LANDSEER.
PETER BLAKE. 1966.

[31] Sir Peter Blake (b.1932)
after Sir Edwin Landseer
The Monarch of the Glen, 1966

Acrylic on canvas, 124.46 x 124.46 cm
Private collection

at the lower right a vibrant label which clearly signifies that this is an exercise in appropriation. The artist's eclectic taste and ingenious reuse of earlier art was one of the keys to his success as a leader of the Pop Art movement in Britain. It frequently involved the redeployment of motifs from popular culture and advertising, an arena that Landseer's work had by this time inhabited for many years. Blake suggested creating a work based on Landseer's *Monarch* to Paul McCartney who acquired the new picture, apparently because the singer owned a painting of Highland cattle. It was therefore associated indirectly with the creation of one of the defining images of the 1960s, as in the year after the pop version of the stag was painted, the two worked on the album cover for the Beatles' *Sgt Pepper's Lonely Hearts Club Band* (1967). Blake's *Monarch* painting was included in the retrospective of his work mounted at the Tate Gallery in 1983 and it was suggested in the catalogue that the 'picture by Landseer is one which, like pop stars, has an existence in the media separate from itself … '. The ability of such potent images to be endlessly recycled and take on a life of their own has more recently been taken one stage further by the designer and artist Peter Saville who created a post-modern tribute to both Landseer's and Blake's work in his *After, After, After Monarch of the Glen*, which was first concieved as a print and then woven as a tapestry. [fig.32].

[32] Peter Saville (b.1955)
After, After, After Monarch of the Glen, 2012
Tapestry, 213 x 151 cm
Dovecot Studios, Edinburgh

It is perhaps clear testimony to the enduring power of Landseer's creation that it continues to be utilised across the full range of the political and artistic spectrums as a signifier of praise and damnation in equal measures. So, for example, John McGrath's play *The Cheviot, the Stag and the Black, Black Oil* which was first performed in 1973 proved to be an immensely popular and powerful polemic that explored Scotland's wealth, how it has been held in the hands of an élite minority, and provided a historical context for the extraction of North Sea oil. More recently Landseer's work and status has also been challenged in works by the artist Ross Sinclair, such

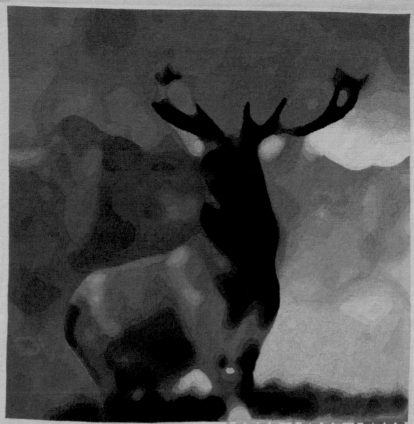

AFTER AFTER AFTER
MONARCH OF THE GLEN
BY SIR EDWIN LANDSEER
BY SIR PETER BLAKE
BY PETER SAVILLE
DOVECOT 2012

as his provocative 2007 installation *Ross Sinclair Versus Sir Edwin Landseer* in Aberdeen Art Gallery.

Set against such creative critiques, the title of Landseer's painting has also been employed in an altogether more celebratory and respectful mode. When the Scottish National Portrait Gallery acquired a new portrait of the Queen, which most unusually shows her in an open air and Highland setting, newspaper headlines, perhaps inevitably, christened it 'The Real Monarch of the Glen' [fig.33].

[33] Julian Calder (b.1945)
Queen of Scots, Sovereign of the Most Ancient and Most Noble Order of the Thistle and Chief of the Chiefs (born 1926), 2010 (printed 2013)

Chromogenic print,
133 × 203.2 cm
Scottish National Portrait Gallery, Edinburgh

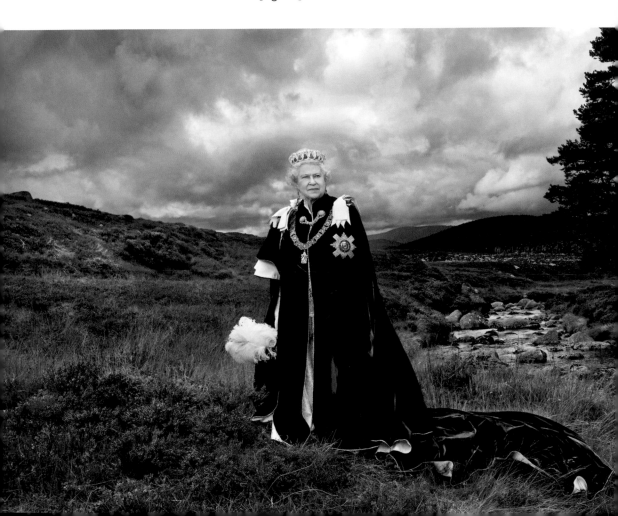

THE MONARCH TODAY

In March 2017, 166 years after it was painted, Landseer's *Monarch of the Glen* finally became a public possession, when it was acquired by the National Galleries of Scotland.

It seems especially appropriate that it now has this status, as for much of its life the picture has played a role in British and Scottish popular culture, being so often reproduced and 'owned' at least by proxy by so many people, whether through engravings or in connection with whisky bottles.

The painting now poses a key question: is it still fitting to promote a work by an English artist who conformed with aristocratic taste, which is clearly cloaked in a romantic view of Scottish culture, as relevant in the twenty-first century? This is an especially compelling issue at a time when Scotland is defining a strong role for itself as a distinctive, modern, democratic and technological nation. Some will undoubtedly conclude that the painting is an anachronism. Others will want, however, to continue to celebrate the picture because of Landseer's remarkable artistry and the way in which it symbolises the natural wonders of the country. What is certain is that his work has retained a powerful quality of recognition and been able to take on a wide range of different roles and interpretations, often simultaneously. It will now be seen by more people than ever before and new debates and artistic responses will undoubtedly develop around it. These may well focus on another fascinating issue: whether the painting fits

into the narrative of Scottish art? In answer to this, perhaps it is helpful to view *The Monarch of the Glen* as an important example of Scotland's art – a more inclusive description which accommodates the work of painters from across Europe and beyond who have contributed to the rich imagery that has come to be associated with the nation. This places it in the company of work by artists such as Benjamin West or Gustave Doré or J.M.W. Turner, all of whom celebrated quintessentially Scottish themes, and whose paintings can be admired in the Scottish National Gallery, alongside the greatest examples of work by Scottish artists.

Art galleries sometimes have a single work in their collections which captures the public imagination and acts as a beacon or emblem for them. For many years the wonderful and idiosyncratic *Skating Minister*, 1784, by Sir Henry Raeburn has fulfilled this role for the Scottish National Gallery. Landseer has perhaps now finally provided him with a serious rival.

A NOTE ON SOURCES & FURTHER READING

SOURCES:

LANDSEER
The key biographical sources on Landseer are Lennie 1976, Ormond 1982 and the DNB. For the early drawings see Owens 2012 and for his connection with the royal family, Millar 1992 and Marsden 2010. Ormond 2005, provides the fullest and most richly illustrated account of Landseer's love affair with Scotland. There is no published catalogue raisonné of Landseer's paintings or drawings.

THE MONARCH OF THE GLEN
For the parliamentary context to the commission of *The Monarch of the Glen* see Robertson 1978. The debate in which Peel describes Landseer is transcribed in *Hansard*. The important connection with Scott's *Stag Hunt* is noted in Holloway and Errington 1978. The acquisition by Landseer of Stubbs's drawings remains somewhat mysterious and is briefly discussed in Owens 2012.

FROM PRIVATE COLLECTIONS TO POP ART
The visit of Queen Victoria to Landseer's house in 1851 is documented in her Journal. For Sir Peter Blake's work see Compton 1983.

FURTHER READING:

BAKER 2011
C. Baker, *English Drawings and Watercolours 1600–1900*, The National Galleries of Scotland, Edinburgh, 2011.

BOASE 1954
T.S.R. Boase, 'The Decoration of the New Palace of Westminster 1841–1863', *Journal of the Warburg and Courtauld Institutes*, vol.17 no.3/4, 1954, pp.319–58.

BRUCE 2013
A. Bruce *et al.*, *Keepers, The Ancient Offices of Britain*, London, 2005.

CANNIZZO 2005
J. Cannizzo, *Our Highland Home: Victoria and Albert in the Highlands*, exh. cat., The Scottish National Portrait Gallery, Edinburgh, 2005.

CHRISTIE'S 2016
Christie's, *Old Masters, Evening Sale*, Thursday 8 December 2016: auction catalogue.

CLARK 1981
R.W. Clark, *Balmoral, Queen Victoria's Highland Home*, London, 1981.

COMPTON 1983
M. Compton *et al.*, *Peter Blake*, exh. cat., Tate Gallery, London, 1983.

DNB
Oxford Dictionary of National Biography: www.oxforddnb.com Accessed March 2017.

DONALD 2007
D. Donald, *Picturing Animals in Britain 1750–1850*, New Haven and London, 2007.

DYSON 1984
A. Dyson, 'Images Interpreted: Landseer and the Engraving Trade', *Print Quarterly*, vol.I, 1984, pp.29–43.

HANSARD
https://hansard.parliament.uk Accessed March 2017.

HAMILTON 2014
J. Hamilton, *A Strange Business: Making Art and Money in Nineteenth-Century Britain*, London, 2014.

HOLLOWAY AND ERRINGTON 1978
J. Holloway and L. Errington, *The Discovery of Scotland. The Appreciation of Scottish Scenery through Two Centuries of Painting*, exh. cat., The National Gallery of Scotland, Edinburgh, 1978.

LENNIE 1976
C. Lennie, *Landseer: The Victorian Paragon*,
London, 1976.

MACKENZIE 2001
J.M. Mackenzie, (ed.), *The Victorian Vision,
Inventing New Britain*, exh. cat., The Victoria and
Albert Museum, London, 2001.

MARSDEN 2010
J. Marsden, (ed.), *Victoria & Albert, Art & Love*, exh.
cat., The Queen's Gallery, London, 2010.

MILLAR 1974
O. Millar, *British Sporting Paintings 1650–1850*,
exh. cat., The Hayward Gallery, London, Leicester
Museum and Art Gallery and the Walker Art Gallery,
Liverpool, 1974–5.

MILLAR 1992
O. Millar, *The Victorian Pictures in the Collection of
Her Majesty The Queen*, 2 vols, Cambridge, 1992.

MILLAR 1995
D. Millar, *The Victorian Watercolours and Drawings
in the Collection of Her Majesty The Queen*, 2 vols,
London, 1995.

NOON 2003
P. Noon *et al.*, *Crossing the Channel, British and
French Painting in the Age of Romanticism*, exh.
cat., Tate Britain, The Minneapolis Institute of Arts
and The Metropolitan Museum of Art, New York,
2003.

ORMOND 1982
R. Ormond *et al.*, *Sir Edwin Landseer*, exh. cat., The
Philadelphia Museum of Art and The Tate Gallery,
London, 1982.

ORMOND 2005
R. Ormond, *The Monarch of the Glen: Landseer in
the Highlands*, exh. cat., The National Galleries of
Scotland, Edinburgh, 2005.

ORMOND 2009
R. Ormond, *Edwin Landseer, The Private Drawings*,
Norwich, 2009.

OWENS 2012
S. Owens, 'Ecorché' drawings by Edwin Landseer,'
The Burlington Magazine, vol.154, May 2012,
pp.337–44.

PASSAVANT 1836
M. Passavant, *Tour of a German Artist in England.
With Notices of Private Galleries, and Remarks on
the State of Art*, 2 vols, London, 1836 (1978 reprint,
introduction by C. J. Bailey).

POINTON 2017
M. Pointon, 'The Iconography of an Image',
Art Quarterly, summer 2017.

REITLINGER 1961
G. Reitlinger, *The Economics of Taste, The Rise and
Fall of Picture Prices 1760–1960*,
London, 1961.

RIDING & RIDING 2000
C. Riding and J. Riding (eds), *The Houses of
Parliament, History, Art, Architecture*, London,
2000.

ROBERTSON 1978
D. Robertson, *Sir Charles Eastlake and the
Victorian Art World*, New Jersey, 1978.

ROSENFELD AND SMITH 2007–8
J. Rosenfeld *et al.*, *Millais*, exh. cat., Tate Britain,
Van Gogh Museum, Kitakyushu Municipal Museum
and the Bunkamura Museum of Art, 2007–8.

SHAWE-TAYLOR 2009
D. Shawe-Taylor, *The Conversation Piece, Scenes
of Fashionable Life*, exh. cat., The Queen's Gallery,
London, 2009.

THOMAS 1983
K. Thomas, *Man and the Natural World, Changing
Attitudes in England 1500–1800*,
London, 1983.

QUEEN VICTORIA
Queen Victoria's Journals online:
www.queenvictoriasjounrnals.org Accessed March
2017.

PROVENANCE

Painted c.1851: intended for the Refreshment Room in the House of Lords as part of an uncompleted sequence of three pictures;

acquired by the 1st Lord Loundesborough;

by descent to his widow, later Lady Otho Fitzgerald;

her sale, Christie's, 10 May 1884, lot 9;

acquired by H.W. Eaton, later Lord Cheylesmore;

his sale, Christie's, 7 May 1892, lot 42;

acquired by Agnew;

acquired by T.J. Barratt;

his sale, Christie's, 11–12 May 1916, lot 67;

acquired by Sir Thomas Dewar;

Dewar's joined Distiller's Company in 1925;

Distiller's Company was acquired by Guinness in 1986;

Guinness merged with Grand Metropolitan to form Diageo in 1997;

Purchased by the National Galleries of Scotland as a part gift from Diageo Scotland Ltd.

With contributions from the Heritage Lottery Fund, Dunard Fund, the Art Fund, the William Jacob Bequest, the Turtleton Trust and through public appeal 2017

DONORS & SUPPORTERS

The acquisition of *The Monarch of the Glen* by Sir Edwin Landseer has been made possible thanks to overwhelming support from the public, the Heritage Lottery Fund, Dunard Fund, Art Fund, private trusts and foundations, and a part gift from Diageo Scotland Ltd.

The National Galleries of Scotland would like to thank all our supporters:

Heritage Lottery Fund
Dunard Fund
The Art Fund
The William Jacob Bequest
NGS Acquisition Fund
 (Scottish Government)
The Turtleton Trust
The K.T. Wiedemann Foundation,
 Inc
The Tam O' Shanter Trust

Bruce Adam
Alexandra Adamson
Dorothy Air
American Patrons of the National
 Library and Galleries of Scotland
Anna Anderson
Christine Anderson
Colin and Lynda Anderson
Fiona Anderson
Jane Anderson
Valerie Anderson
Hamish and Marjory Archibald
Robin G. Arnott
Thomas Ashe
Adrienne Assmus

The Babbs Family
Elizabeth Baird
Shirley Ballantine
Anne Bambridge
John Banks
Prof Rosaline Barbour
Suzanne Barnett
Alisdair Barron
Maarten Beijen
John Bennett
Karen Berry
William and Elizabeth Berry
Margaret Bevans
Marion Black
John Blaikie
Alison Boreham
Hugh Bowman
Maureen Boyle
Ailsa Brannan
John Michael Bremner
P. Bremner
Judith Bronkhurst
John Brown
Mary Brown
Patricia Browne
Iain Bruce
Dr Lorraine Bruce
Neil Bruce
Robert Brudenell
Ann Bukantas
Catriona Burns
Gail Burton
Jennifer, Marchioness of Bute
Celia Butterworth
James Buxton
M.A. Calder
Sir Kenneth Calman
Elizabeth Campbell
Toby Campbell

Bliss and Brigitte Carnochan
Kathleen Carolan
Charles Carson
Joan Carson
Jacqueline Cates
J. Chalmers
John and Gwyneth Chalmers
Thomas Chambers
Bridget Clarke
Janet Clarke
Jenny Clarke
Patricia Clayton
Gavin Cleland
Vivienne Cockburn
Blandine Conner
Greg Cooper
Jamies Cormie
Alan Couper
Dorothy Cowan
Annabel Crane
Dr Richard Crockett
Hugh Cuthbertson
Frances Anne Dalrymple
Hew Dalrymple
Engelina Davids
Prof. Neil Davie
Felicity De Salis
Karen Delaney
Frances Dent
Eleanor Devenney
Delma Dewar
Angela Dey
Lilian Dick
Elizabeth Anne Dickie
Prof Rebecca Dobash
Anne Donald
Patrick Donlea
Alan Downie
Elizabeth Downing

Morag Dunlevy
Allan Duthie
Edinburgh Decorative and Fine
 Arts Society
Christian Elder
Karen Elder
J.B. Ellis
Heather Emerson
Dr Elwyn Evans
Guillaume Evrard
Fergus Ewing MSP
Cosmo Fairbairn
Jan Fairgrieve
Barbara Farley
Lesley Farnan
Sheila Findlay
Dr Lorna Finlay
Dr Niall Finlayson
Joan Fitzpatrick
Jean S. Fleetwood
W.D. Foord Charitable Trust
David Forfar
William Fortescue
Petrina Fortune
Rev'd Canon Dean Fostekew
Sir Charles and Lady Fraser
Susan Fraser
Friends of the National Galleries
 of Scotland
David Fyfe
E. J. Bruce Galloway
John and Jennifer Garbett
Dr Sally Garden
Mary Gass
Gael Gellatly
Gavin and Kate Gemmell
Dr Angus Gibson
Nicola Gibson
Peter Gilbert

Carol Gillies
Ian Gilvear
Andrew Glasgow
Sandra Goldie
Nick Gosling
Lachlan Goudie
Isabel Goundry
Prof Peter Grant
Samantha Grant
Sheena Grant
Myke Grantham
Jim and Jennifer Gray
Samantha Grayson
Kenneth and Julia Greig
Nicholas Grier
A.J. and E.M. Grieve
Margaret Hamilton
In memory of Sally Connally
 Hardie
Marion Harvie
Laura Hayward
Neil Heads
David Hebden
Fiona Henderson
Robert Henderson
Sheena Hendrie
Gary Heron
Ron Hill
Alexander Hogan
John Hogarth
Thomas Hone
Margaret Hood
Barbara Horn
Jean Horn
Johann Horsburgh
John Horsburgh
Catherine Howlett
In memory of Mr and Mrs T.N.
 Hughes-Onslow

William Humphries
Maggi Hunt
Eirene Hunter, in memory of my
 dog Polly
David Hutchison
Sarah Ingham
James Innes-Macleod
Gail Jack
Maura Jack
Gemma Jamieson
W.M. Jamieson
Bernice Jones
Lauren Jones
Trevor and Ishbel Jones
Elaine Jukes
Gary Kedney
Fiona Kennedy
Prof Jessie Kennedy
Nicola Kenny
Carol Kerr
Anne Kershaw
Kimberly C. Louis Stewart
 Foundation
Dianne King
Jamie Kirkwood
L.A. Dollimore
Prof. James Laidlaw
Margaret Laing
Judith Lamb
Brian Lanaghan
John Lappin
A. Lawson
Dianne Lawson
Margaret Lawson
Thomas Lawson
Trevor Leach
Kevin Leary
Janet Lee
David Leslie

ACKNOWLEDGEMENTS

A number of people have very generously assisted in the creation of this book. Helen Smailes and Patricia Allerston kindly reviewed the text and made many useful suggestions and corrections. Publication has been seamless thanks to the expertise of Sarah Worrall, Jennifer McIlreavy, Robert Dalrymple and Steven Morgan. Others who have provided invaluable help include Samantha Lagneau, Patricia Convery, Lorraine Maule, Elinor McMonagle, Lucy Whitaker, Martin Clayton and John Leighton. CB

IN REMEMBRANCE OF SIR EDWIN LANDSEER.
*"He has not lived in vain whose teaching tends
To human sympathy with our dumb friends"*

[34] Albert Mendelsshon,
after Thomas Selby Cousins
In Remembrance of Sir Edwin Landseer, 1873
Albumen cabinet card, 13.1 cm x 10.2 cm,
National Portrait Gallery, London